This library edition published in 2012 by Walter Foster Publishing, Inc.
Walter Foster Library
Distributed by Black Rabbit Books.
P.O. Box 3263 Mankato, Minnesota 56002

Printed in Mankato, Minnesota, USA by CG Book Printers, a division of Corporate Graphics.

First Library Edition

Library of Congress Cataloging-in-Publication Data

Learn to draw reptiles & amphibians.
 p. cm.
 "Illustrated by Diana Fisher."
 ISBN 978-1-93630-950-4
1. Reptiles in art--Juvenile literature. 2. Amphibians in
art--Juvenile literature. 3. Drawing--Technique--Juvenile literature.
I. Fisher, Diana, illustrator. II. Walter Foster (Firm) III. Title: Learn
to draw reptiles and amphibians.
 NC783.8.R45D73 2012
 743.6'79--dc23

 2011046097

052012
17679

9 8 7 6 5 4 3 2 1

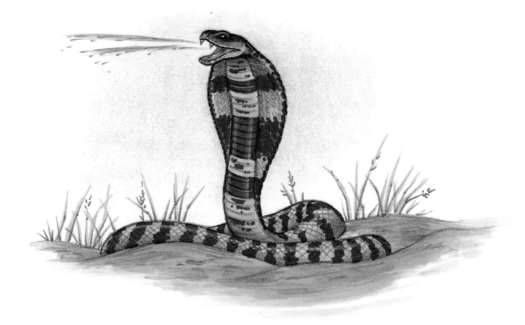

learn to draw

Reptiles & Amphibians

Learn to draw and color 29 different reptiles and amphibians, step by easy step, shape by simple shape!

Illustrated by Diana Fisher

Getting Started

When you look closely at the drawings in this book, you'll notice that they're made up of basic shapes, such as circles, triangles, and rectangles. To draw all your favorite creatures, just start with simple shapes as you see here. It's easy and fun!

Circles are the base of this gecko's head, its eyes, and its toe pads.

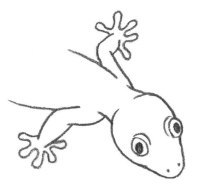

Ovals are good for drawing a turtle's shell, as well as heads and feet in profile.

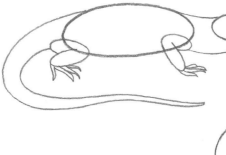

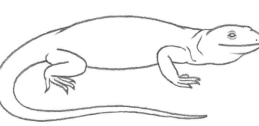

Squares are perfect for drawing boxy heads, like the one on this turtle.

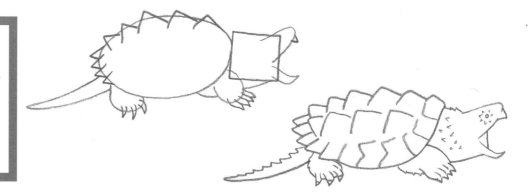

Coloring Tips

There's more than one way to bring scaly snakes and colorful toads to life on paper—you can use crayons, markers, or colored pencils. Be sure you have plenty of good "reptile colors"—black, brown, green, gray, and yellow, plus orange, red, and even blue.

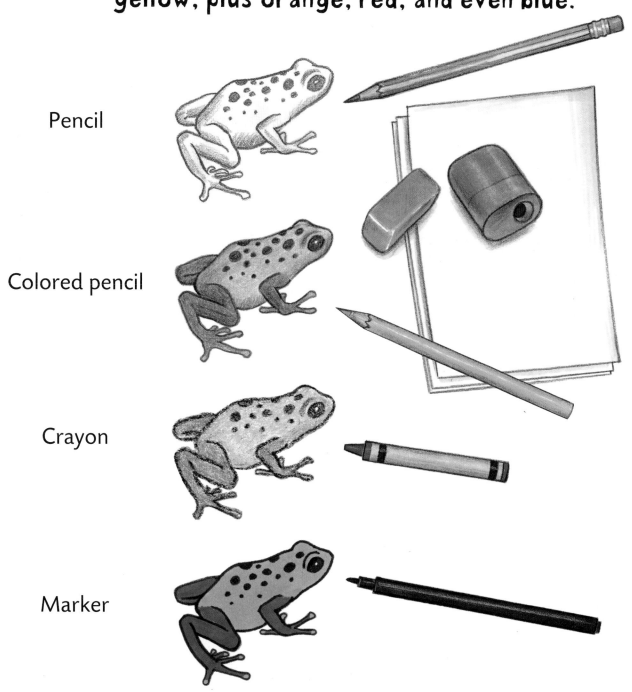

Pencil

Colored pencil

Crayon

Marker

Green Anaconda

The muscular body of the world's largest snake is covered in black and green spots, and colorful stripes define its eyes.

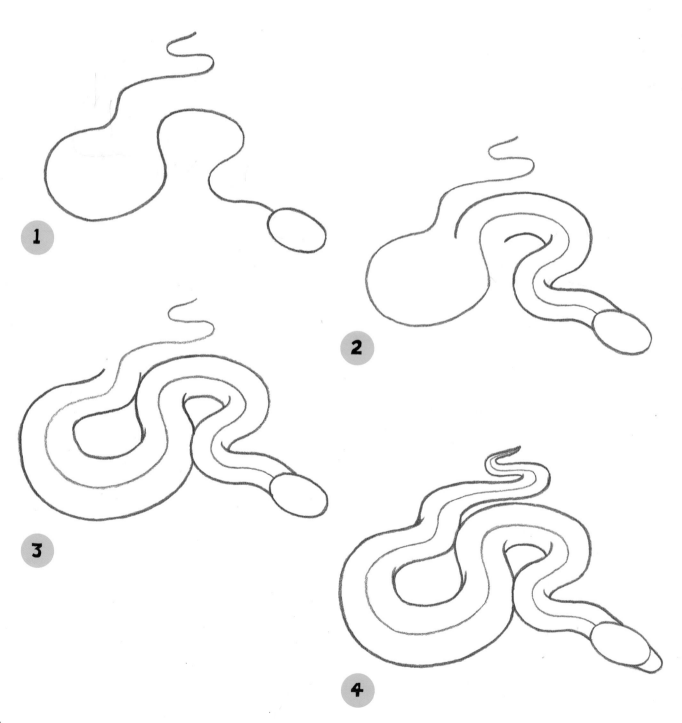

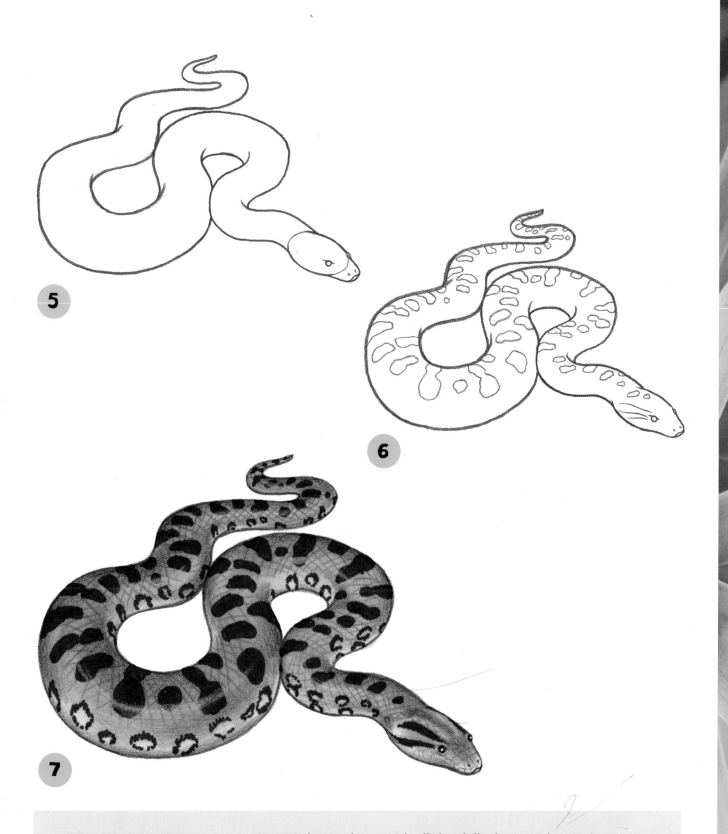

5

6

7

fun fact

Anacondas are born with all the skills they need to survive—
including an incredibly slow-working digestive system.
After a large meal that can take days or weeks to digest, an anaconda
may not eat again for up to two years!

Boulenger's Asian Tree Toad

Here's a tiny toad worthy of your attention, warts and all! Why? Its special sticky toes enable both clinging and climbing.

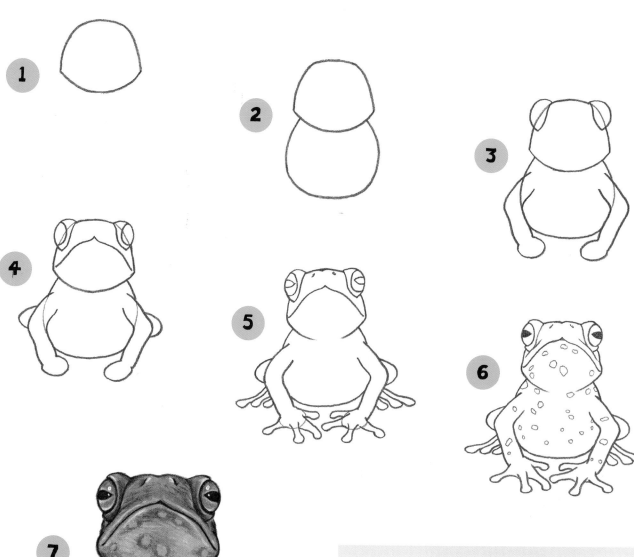

fun fact

Like all other toads, this tree-climbing amphibian has paratoid glands behind its eyes. They produce a poison that can paralyze or kill small animals—now that's a look that could kill!



Gila Monster

The forked tongue on this colorful lizard isn't just for show—it's used to "smell" the gila monster's prey!

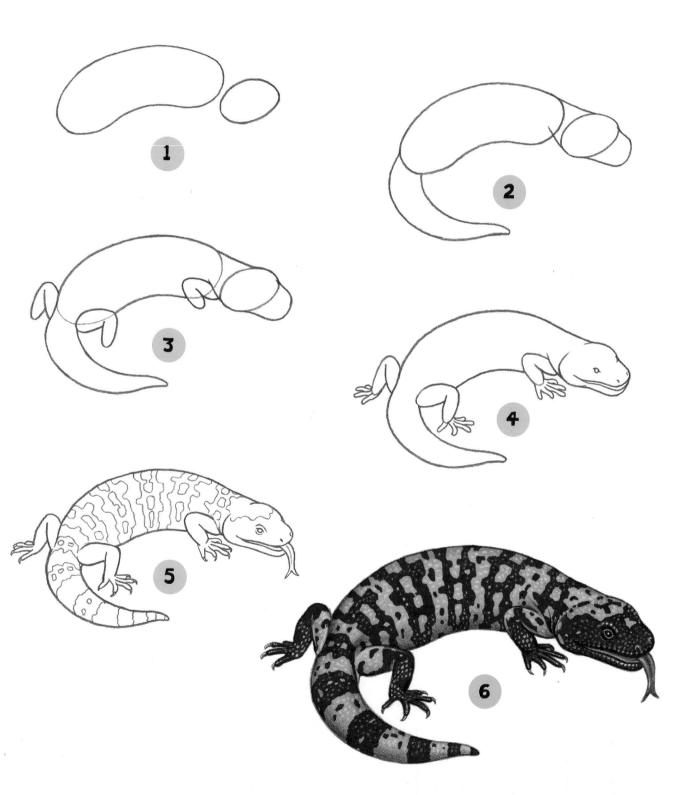

Central Bearded Dragon

Spiny scales are not unusual for lizards, but puffy beards are! When threatened, this dragon inflates its fringed throat with air.

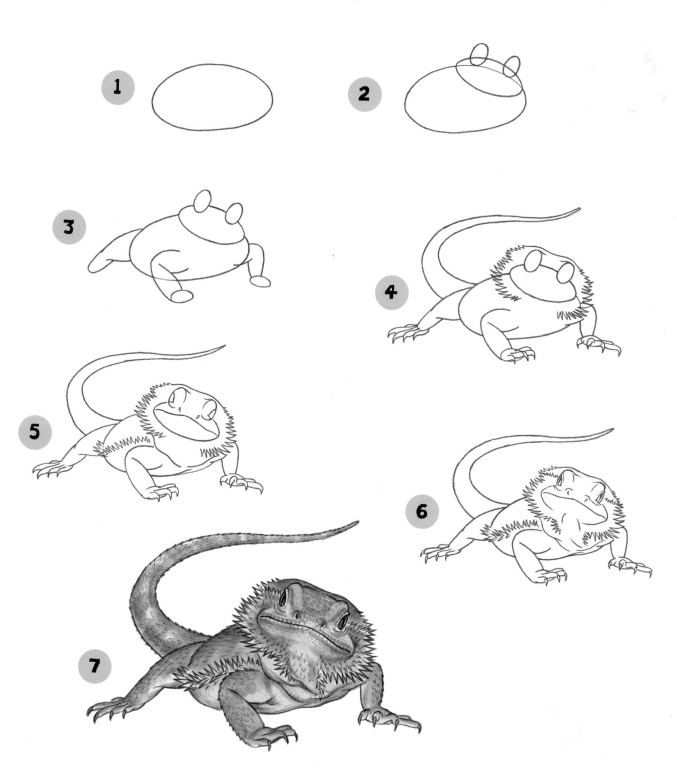

Ocellated Skink

The shimmering scales of this snakelike creature would fit in underwater. But this skink prefers burrowing underground.

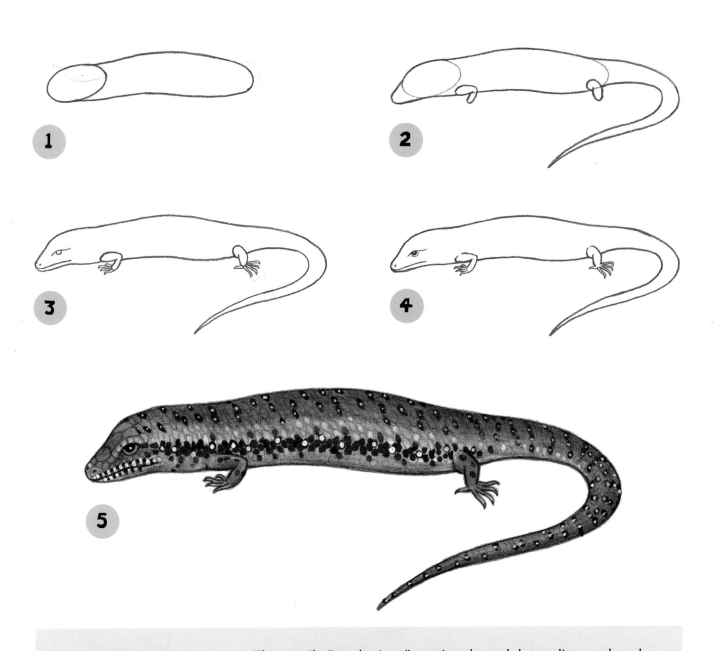

fun fact

This reptile "sandswims," moving through loose dirt, sand, and rocks with a rising-and-falling motion. It has the benefit of smooth scales that keep mud from clinging to its body, and eyelids—a rare feature for a sand-burrowing lizard!

Jackson's Three-Horned Chameleon

only the male of this species looks positively prehistoric—its three "horns" make it look like a distant relative of the triceratops!

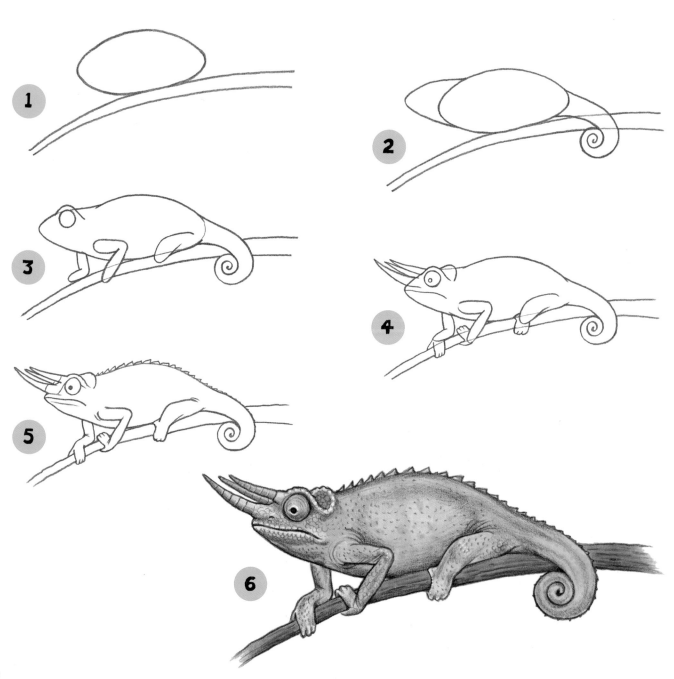

Alligator Snapping Turtle

The sharp, pointy shell—or "carapace"—of this snapping turtle is almost as interesting as its powerful hooked jaw!

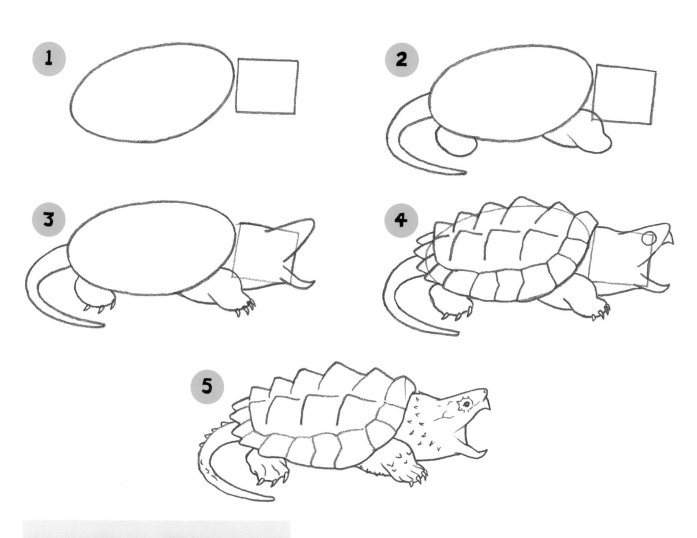

fun fact

The alligator snapping turtle doesn't chase after its food—it lures it straight into its mouth! It simply opens its jaws to reveal a wormlike attachment, which it wiggles about to attract unsuspecting fish.

Australian Frilled Lizard

This small reptile has a fancy frill that folds in neat pleats on its neck when it's calm, but it puts on quite a show when threatened!

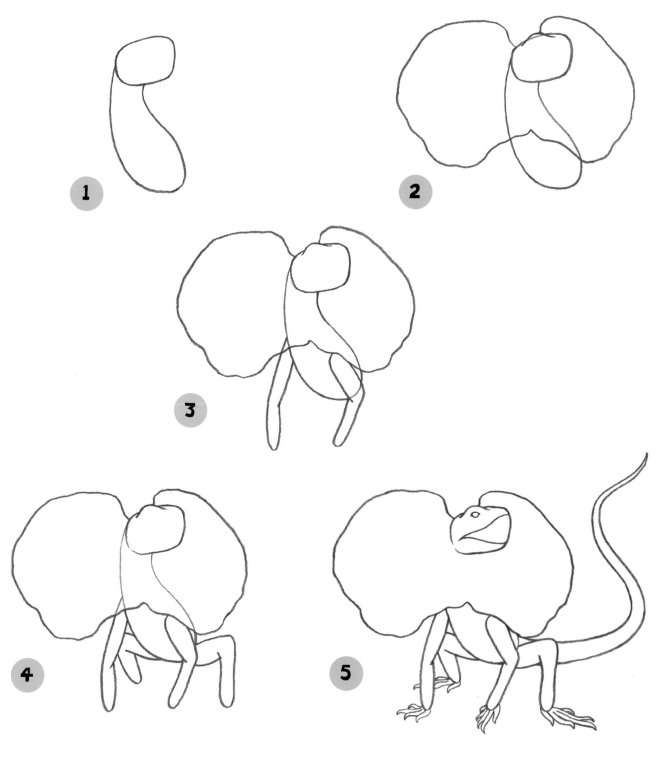

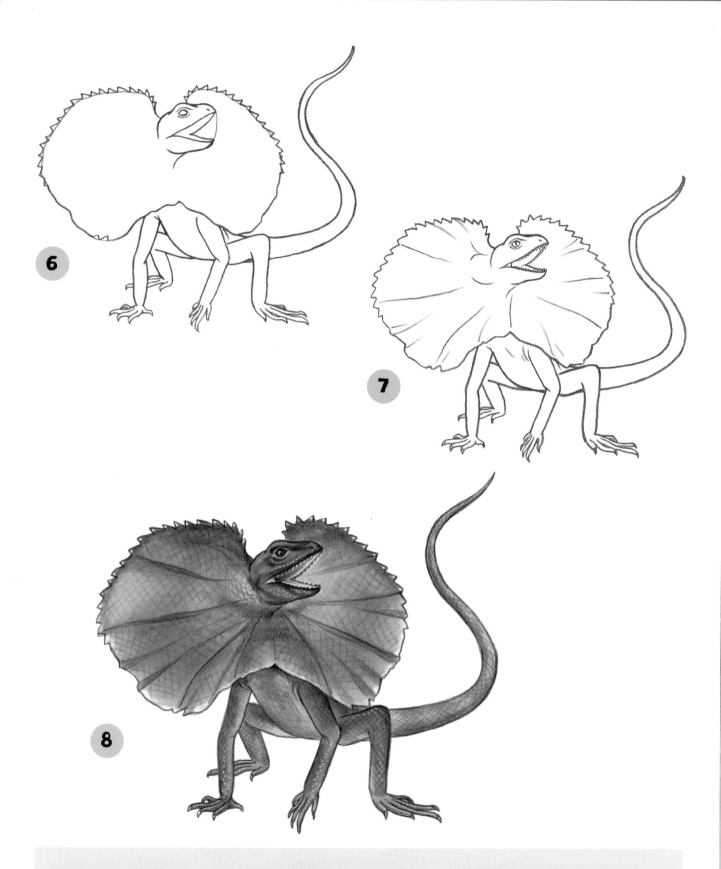

6

7

8

fun fact

This lizard stands up to predators—as a last resort! First it will lay low to the ground, camouflaging its body. If the threat remains, it will raise its frill, open its colorful mouth, and whip its tail in a menacing fashion. Finally it will raise its body on its hind legs, hiss, and jump at the predator!

American Alligator

An alligator's powerful tail accounts for half of its length—and it's the alligator's tail that makes it such a good swimmer!

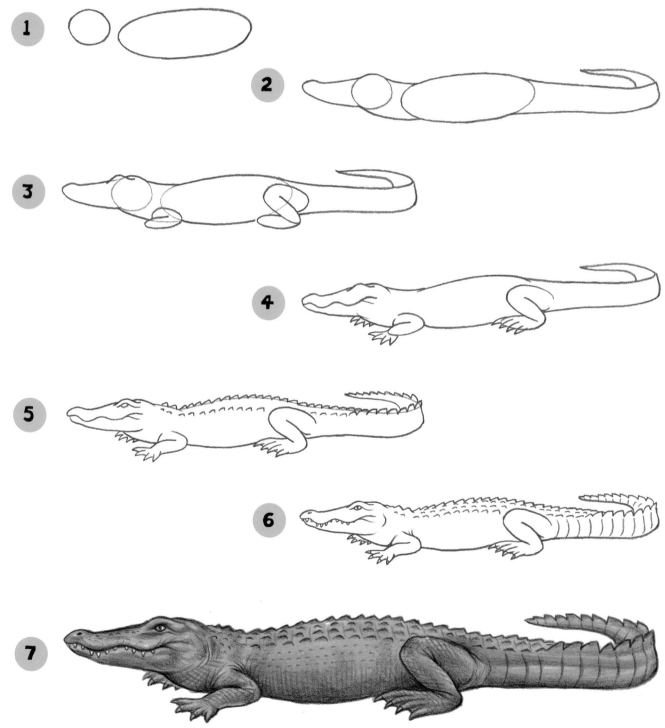

Red-Eyed Treefrog

With its large red eyes, bright green skin, and sticky toe pads, it's hard to confuse this rainforest-dwelling hopper with any other!

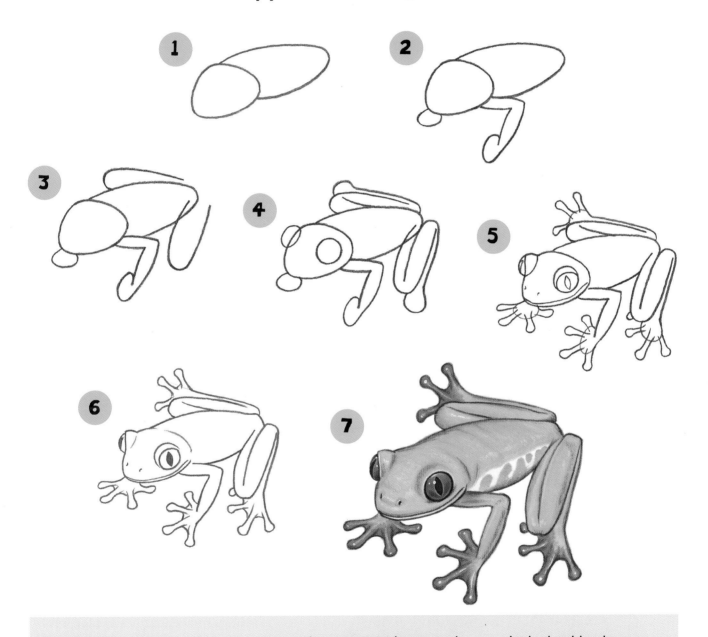

fun fact

It can change its vivid green color to a shade that blends better in its environment, but this frog "flashes" its other colors for protection. Suddenly opening its red eyes or displaying the blue stripes on its midsection can startle or confuse a predator, giving the frog time to hide or escape!

Reticulated Python

"Reticulated" means netlike, which is how this patterned python got its name. Meet one of the world's longest snakes!

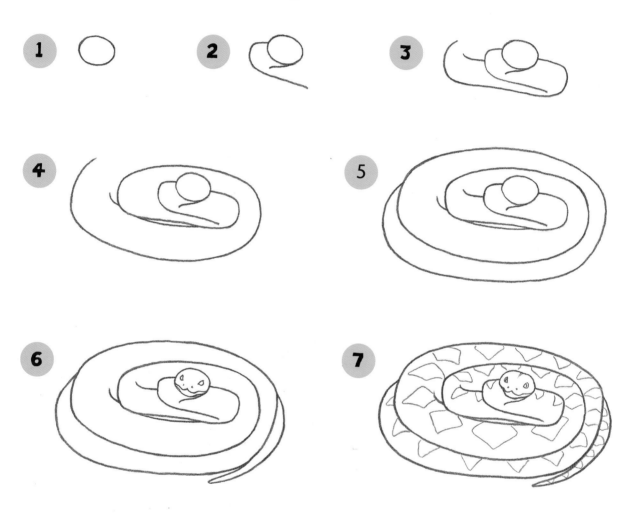

1

2

3

4

5

6

7

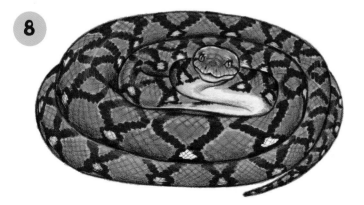

8

fun fact

Pythons move at about 1 mile per hour, but there's no need for them to be quick. They use sight and smell to ambush their food, relying on heat-sensitive pits along their jaws to sense their prey!

Snakeneck Turtle

This Australian turtle has a unique talent—it can stand at the bottom of a river and use its long neck to peek out at the surface.

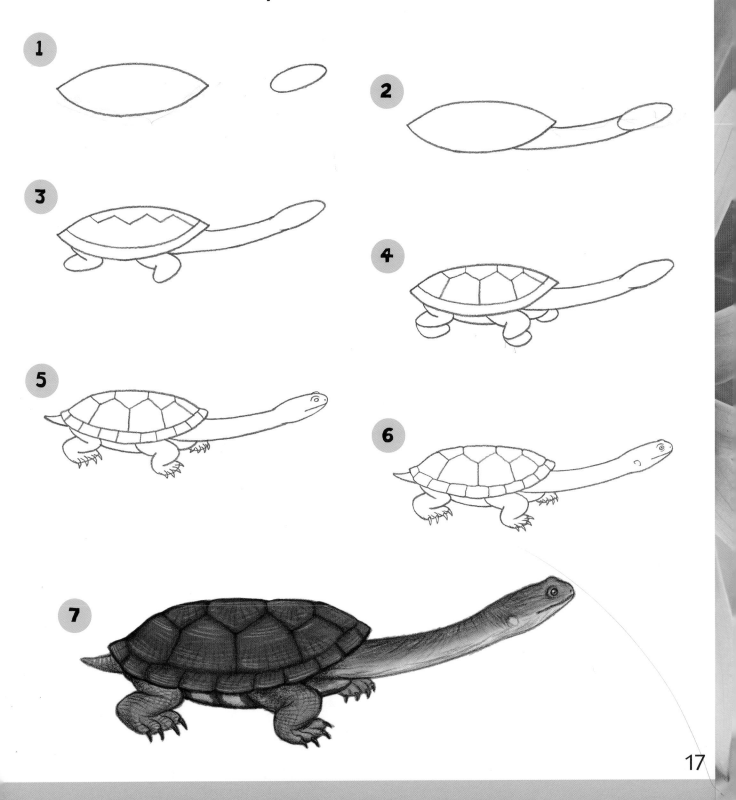

Green Iguana

The iguana's versatile tail acts as a whip in fights and as a propeller when swimming. It also can be shed if the lizard's in danger!

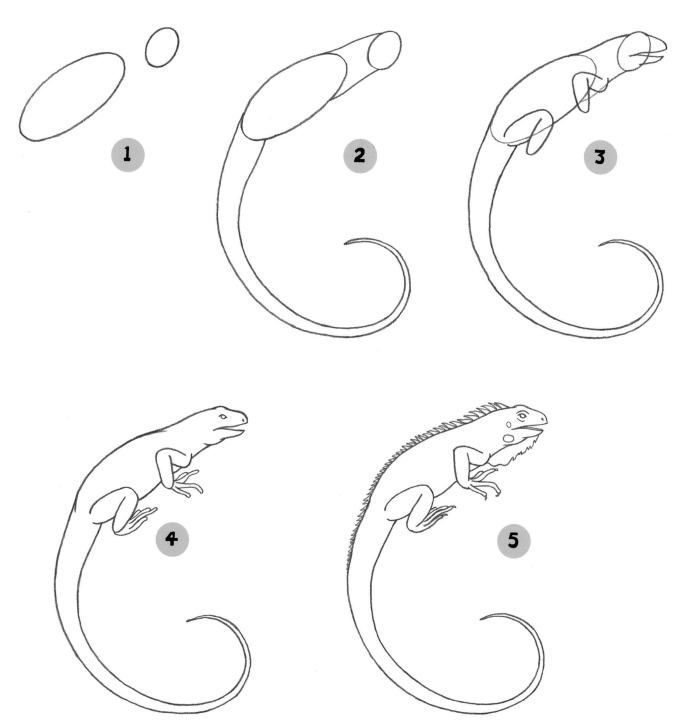

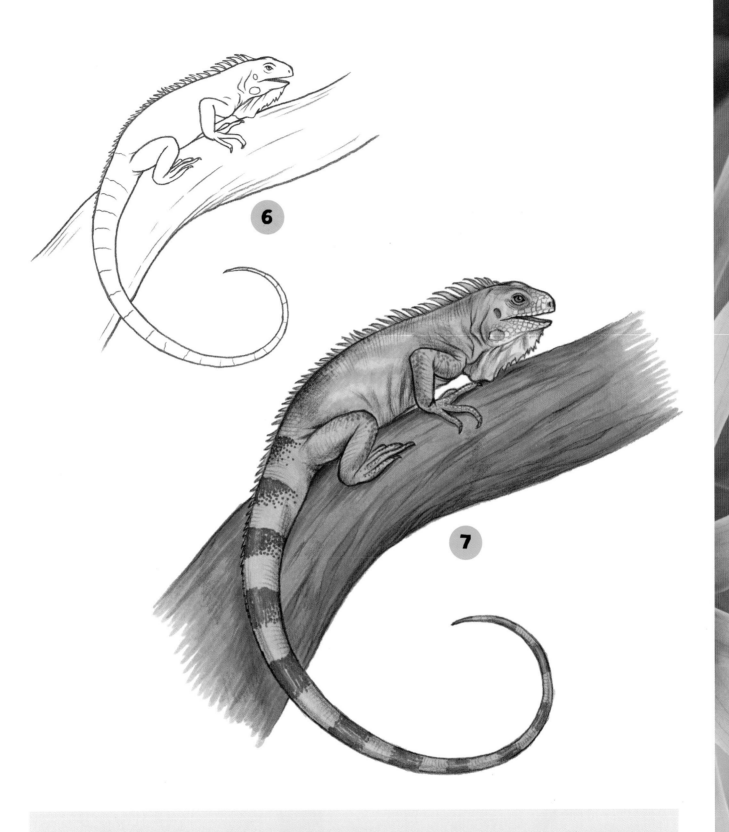

6

7

fun fact

In the wild, green iguanas live in tropical forests. They like to spend their time high in the treetops, basking in the sun. If possible, they like to be in trees that are above water, about 40–50 feet high. If a predator shows up, these agile lizards can drop into the water and stay under until the threat is gone. What a disappearing act!

Natural Talents

Ever seen a reptile fly? change color? Spit venom? check out these talented specimens — then try drawing them in action!

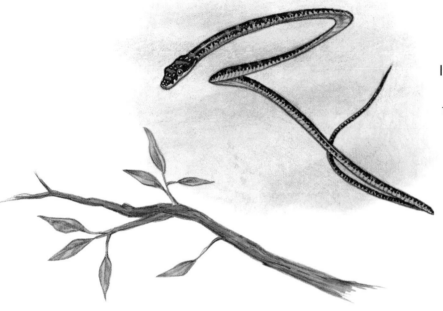

The paradise flying snake is the most colorful of the flying snakes. (Yes, there are a few!) It can curve its body to become a glider, allowing it to "fly" from treetop to treetop or to drop to the ground for a quick escape.

As if the king cobra's bite weren't severe enough, this poisonous snake can also spit venom up to a distance of eight feet! The poison can sting, paralyze, and blind.

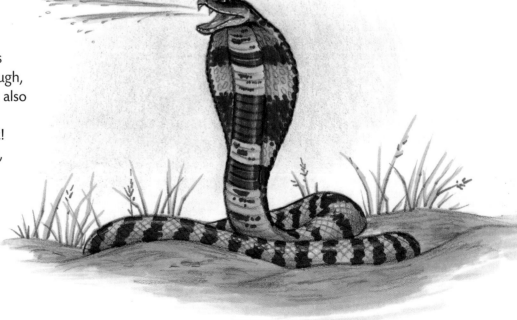

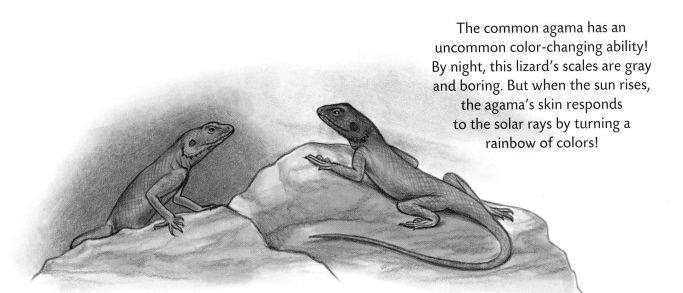

The common agama has an uncommon color-changing ability! By night, this lizard's scales are gray and boring. But when the sun rises, the agama's skin responds to the solar rays by turning a rainbow of colors!

Look there! What's that? It may appear to be a pile of dead leaves at first glance, but that's just good hunting camouflage. The Asian horned frog's drab coloring and unusual shape provide the perfect disguise.

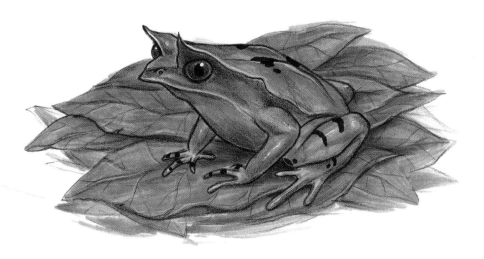

A pancake tortoise begins life with a rounded shell, but its carapace flattens as the tortoise ages. The strange shape gives this turtle the unique ability to squeeze between tight rocks in its natural mountain habitat!

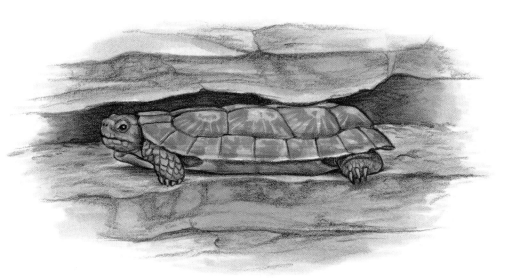

Sonoran Green Toad

A vivid green color and black netlike pattern distinguish this desert-dwelling hopper, which is among the smallest of the toad species.

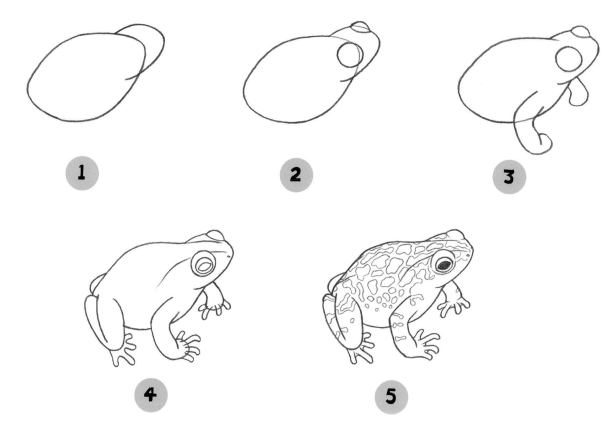

1

2

3

4

5

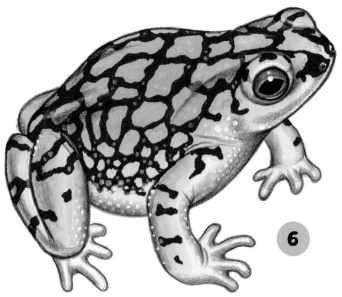

6

fun fact

Have you ever heard the call of a toad? Some sound like a noisy sheep, while others sound like they're snoring! This toad makes a high-pitched call that sounds like a combination of a buzz and a whistle, and can be heard at quite a distance—but only at night, since these toads are nocturnal.

Tokay Gecko

The largest Asian gecko has a heavy body and big, striking eyes. Its distinctive blue-gray skin is enhanced by its polka-dot markings.

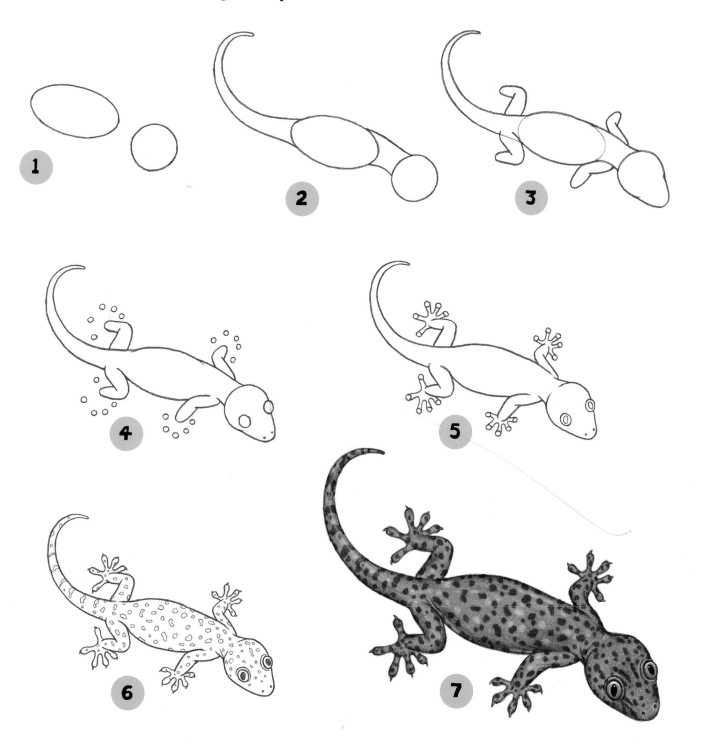

Galapagos Tortoise

This ancient-looking tortoise's massive, curved shell and heavy, thick limbs contrast with a long, slender neck and small head.

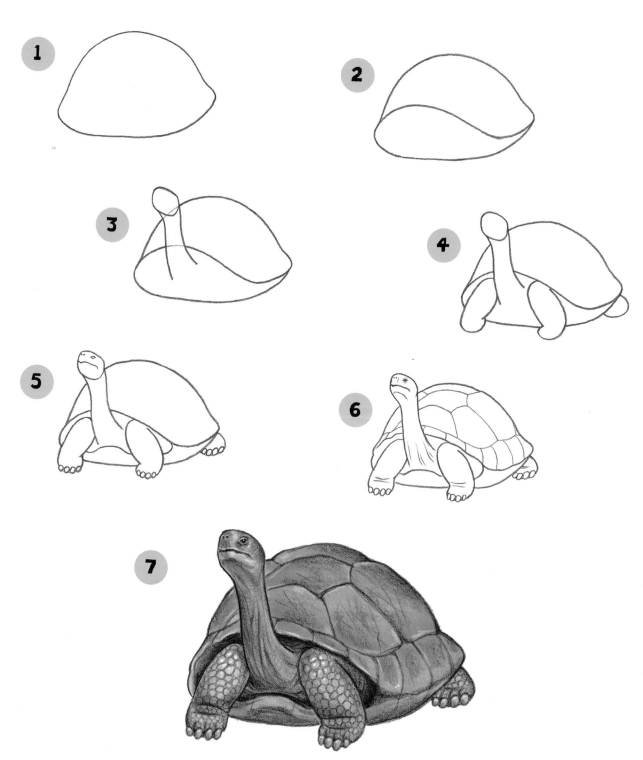

Marbled Newt

All newts have thin bodies, long tails, and short legs. But only the marbled newt has such an unforgettable green color!

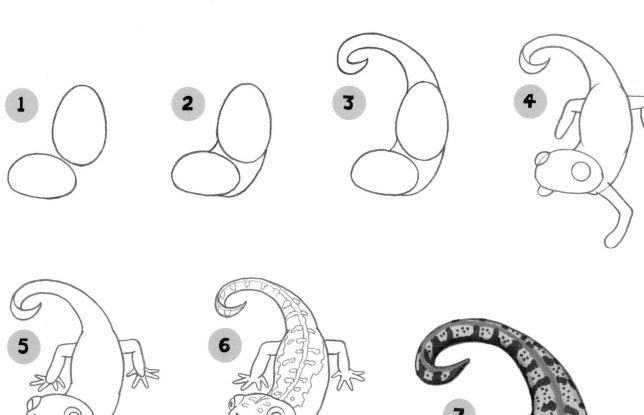

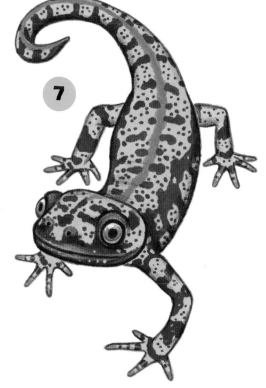

fun fact

This European newt has true self-healing powers! If it loses a limb (such as an arm or a leg), it will grow one back in its place! This talented species can only be found in Spain and in the south of France.

Thorny Devil

covered in cactuslike spines from head to toe, this lizard looks mighty intimidating—until you learn it's only palm-sized!

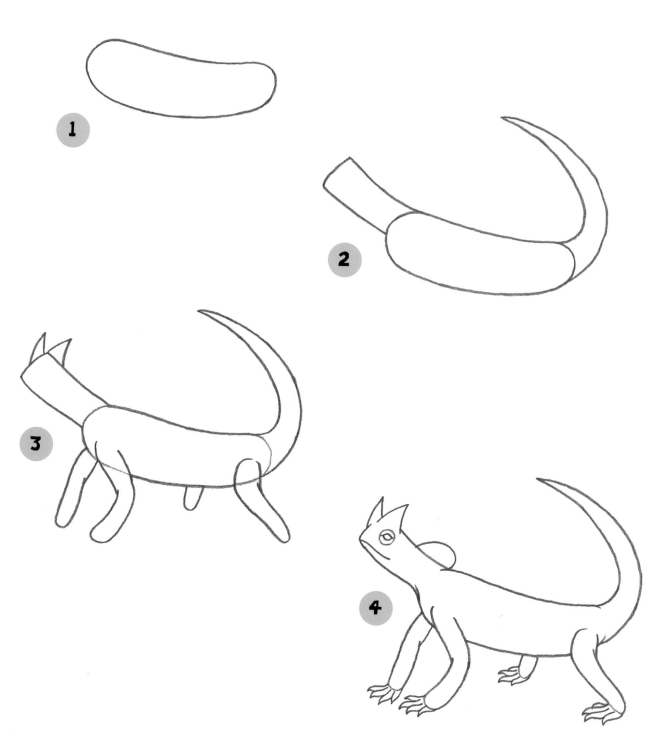

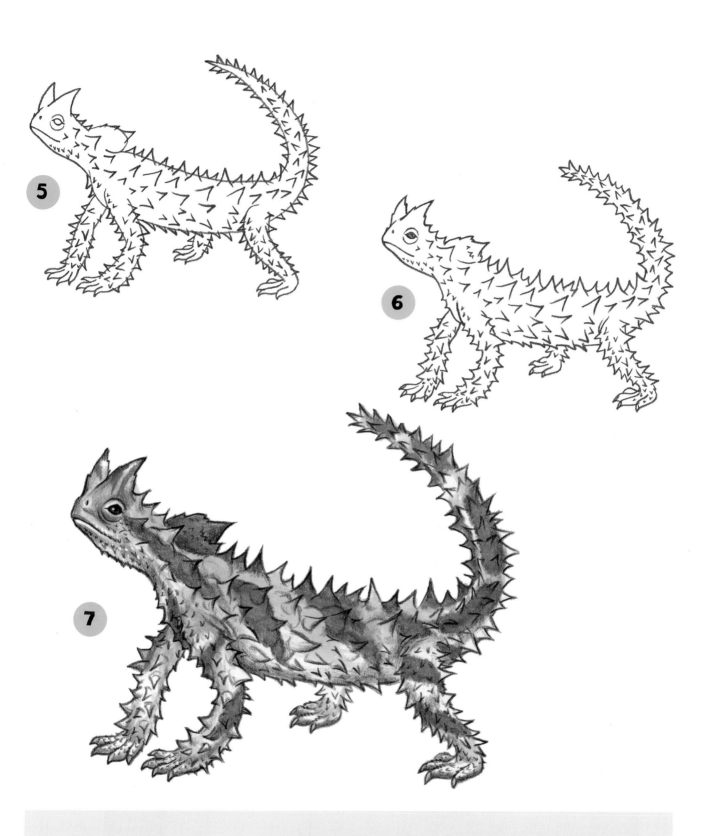

5

6

7

fun fact

Despite its fierce appearance, the thorny devil isn't at all threatening. This tiny, slow-moving creature grows to be 8 inches at most! And it's one of the least aggressive reptiles—when approached by a predator, it simply hides or pulls its head between its front legs for protection.

King Cobra

This snake rears off the ground and flattens its wide hood if threatened—characteristics that make the cobra instantly recognizable.

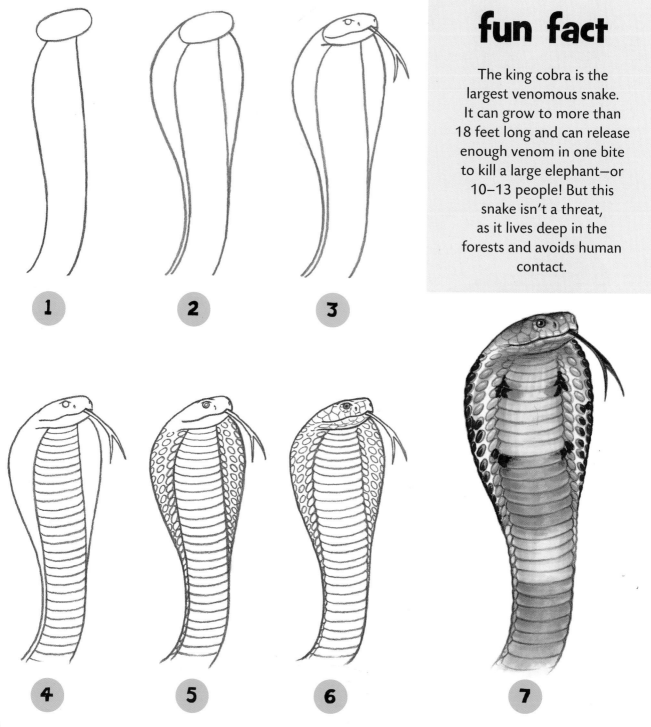

fun fact

The king cobra is the largest venomous snake. It can grow to more than 18 feet long and can release enough venom in one bite to kill a large elephant—or 10–13 people! But this snake isn't a threat, as it lives deep in the forests and avoids human contact.

White-Throated Monitor Lizard

This rough-skinned reptile has a short head but a long tail—which can be up to twice as long as its body!

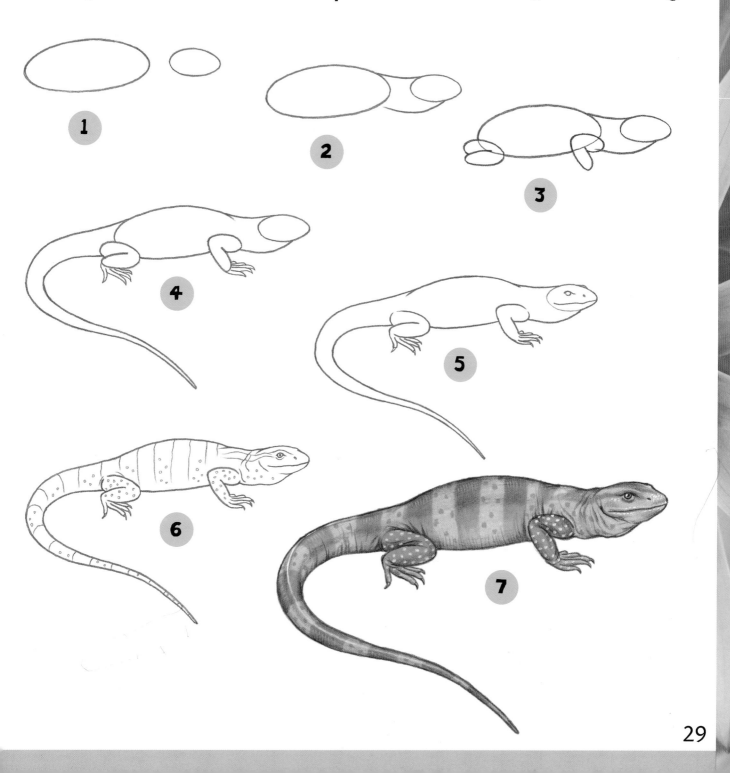

Blue Poison-Dart Frog

Small but dangerous, the intense coloring of this endangered tree-climber lets predators know that it is extremely poisonous!

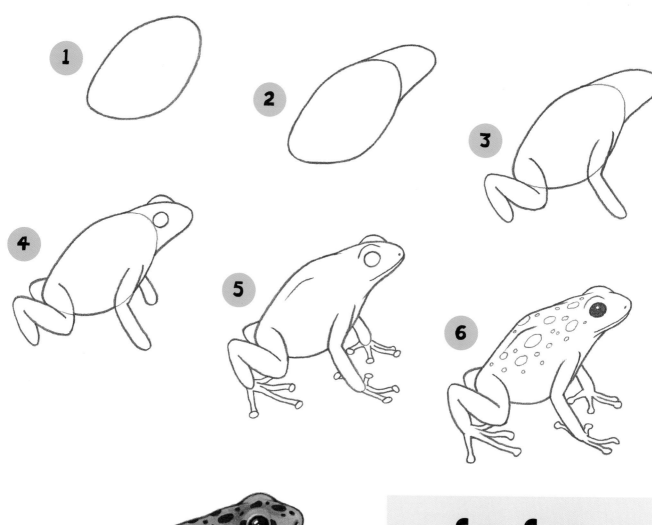

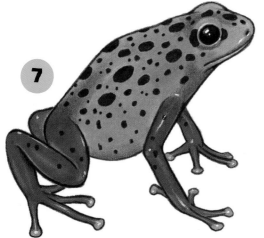

fun fact

Members of one Colombian rainforest tribe use leaves to capture these frogs, killing them for their poison—which they use to tip their blow-dart arrows. The poison is so toxic that one drop can kill an adult human!

Madagascan Leafnose Vinesnake

When this snake is still, its unusual snout camouflages it in the trees. The female has the most elaborate snout; it looks like a fir cone!

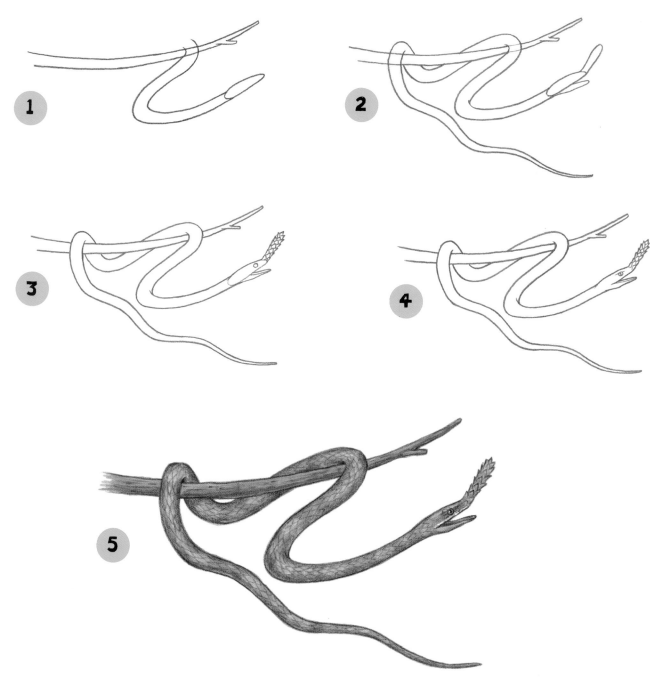

American Green Anole

The dewlap of a male anole is usually bright pink. When courting a female anole, the male will "flash" his bright colors to get her attention!

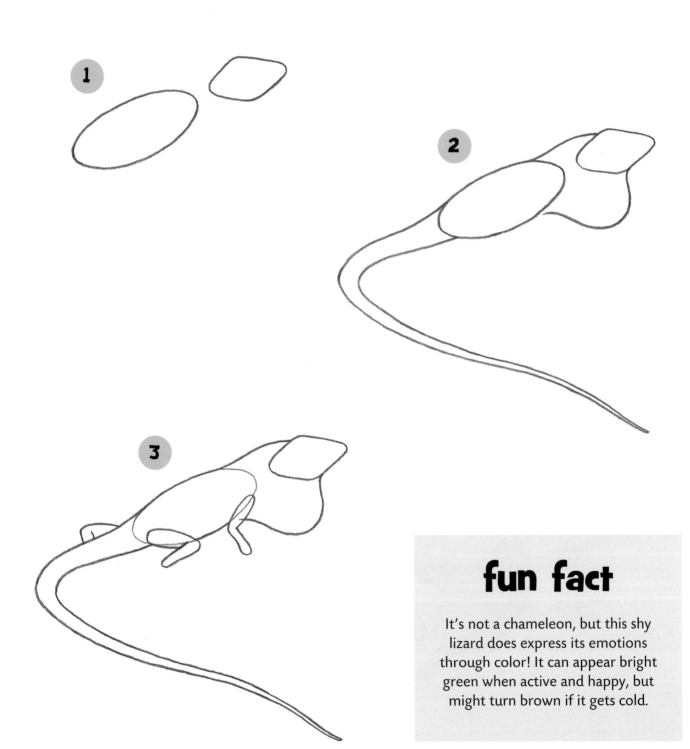

fun fact

It's not a chameleon, but this shy lizard does express its emotions through color! It can appear bright green when active and happy, but might turn brown if it gets cold.

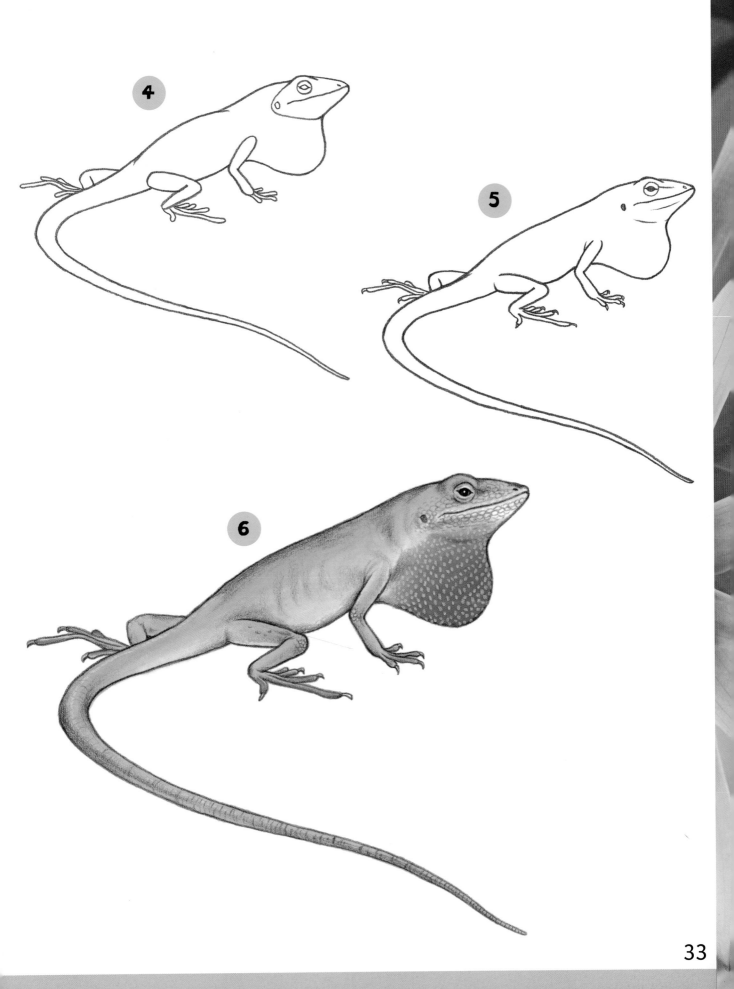

Emerald Tree Boa

Adults of this strong, tree-climbing species have a vibrant green color. But the young can be red or yellow until one year of age.

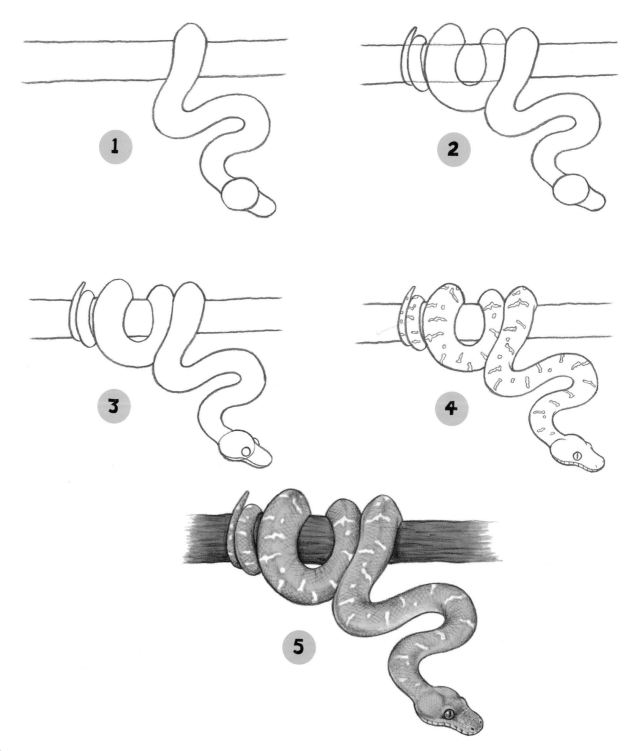

Tuatara

This unique reptile can only be found in remote New Zealand, and its closest dinosaur relatives went extinct over 65 million years ago!

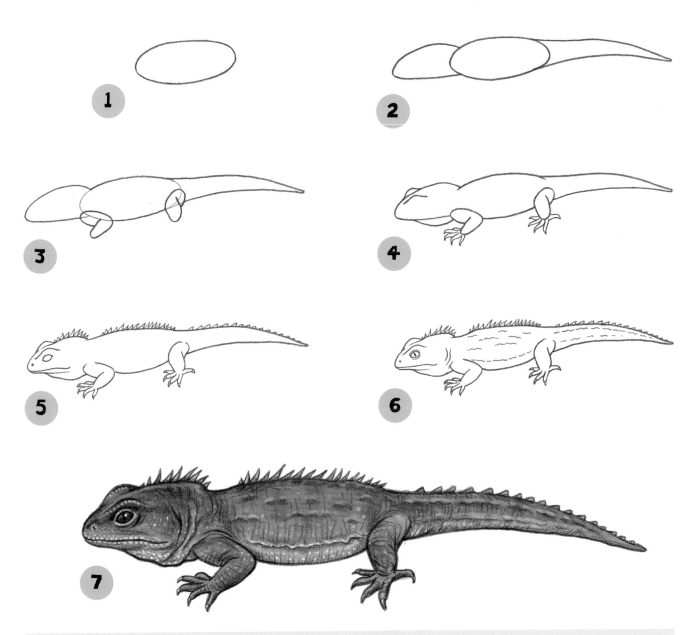

fun fact

The tuatara has three "eyes"—two you can see and a third hidden atop the reptile's head. The third eye has a retina, lens, and even nerve endings, but it isn't used to "see" the visual world. Instead it senses light, and it may help the tuatara judge the time of day or the season.

Red Salamander

This poisonous salamander has no lungs, so it must use its external gills to breathe. The older it gets, the darker its spots become.

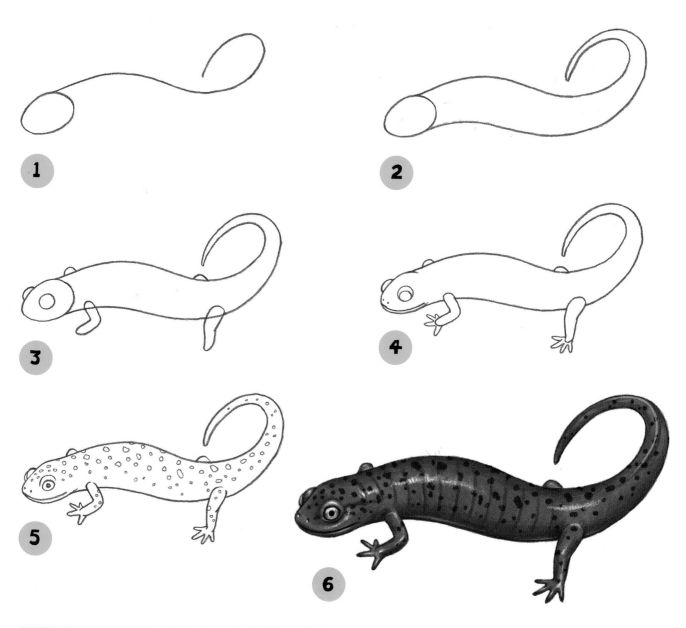

fun fact

All newts are salamanders, but not all salamanders are newts. The word "salamander" refers to an entire group of amphibians that have tails as adults. But "newt" is more specific—it describes salamanders that spend most of their time living on land.

Common Box Turtle

Most turtles retreat into their shells when in danger, but only the box turtle can hide its entire body in its encapsulating carapace!

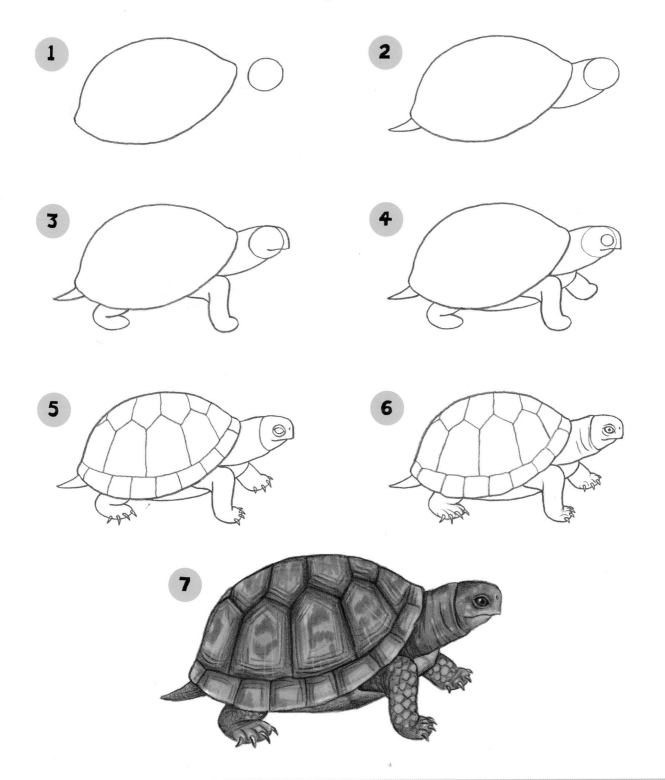

Western Rattlesnake

camouflage is this snake's best trick. But if its sandy body and golden eyes blend in, its rattle will alert you to its presence!

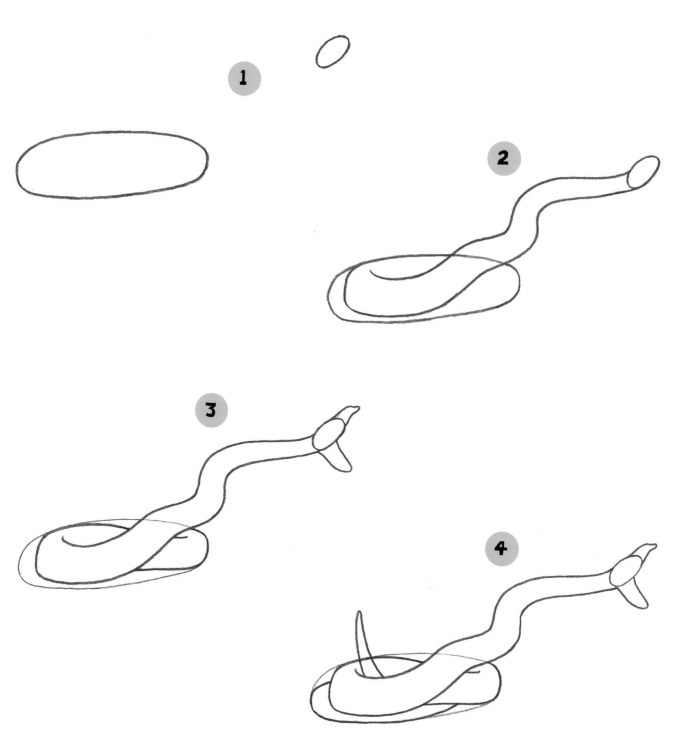

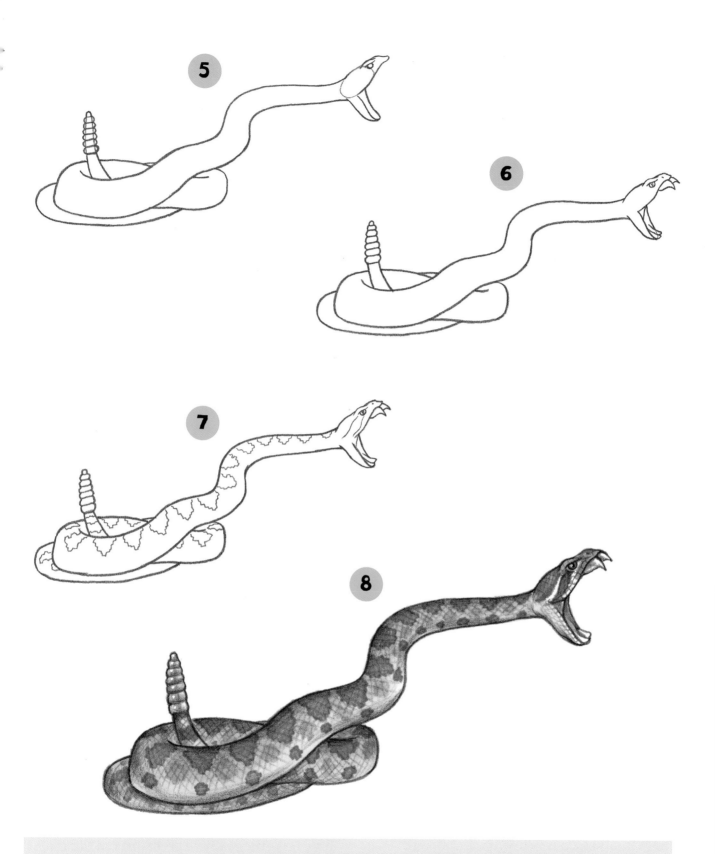

fun fact The rattlesnake's "rattle" is a series of keratin rings that create a hissing sound when vibrated. The rattle grows by one segment each time the snake sheds its skin. But you can't tell the snake's age by the number of segments, as snakes often shed their skin more than once a year.

Armadillo Girdled Lizard

Sharp and prickly, this little lizard's best defense is its body armor. The tough exterior is hard for predators to bite through.

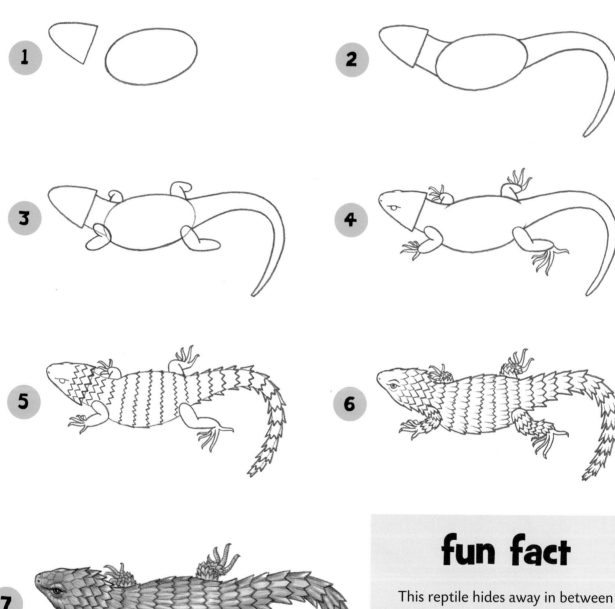

fun fact

This reptile hides away in between rocks, where predators can't reach. But when caught in the open, this wily lizard will bite its own tail, forming a ball to protect its soft belly—just like an armadillo!